HEADS OF THE MASTERS

ANNE ANDERSON

Papier-Mache Press
Watsonville, CA

02 01 00 99 98 5 4 3 2 1

ISBN: 1-57601-054-6 Hardcover

Design and composition by Elysium
Author photo by Susan Bradley
Accompanying artist text by Shirley Coe and Papier-Mache Staff
Proofreading by Kimberly McGinty

Library of Congress Cataloging-in-Publication Data

 Anne, Anderson, 1917–
 Heads of the masters / Anne Anderson.
 p. cm.
 ISBN 1-57601-054-6 (alk. paper)
 1. Anderson, Anne, 1917– —Pyschology. 2. Toilets in art. 3. Fantasy in art.
 4. Imitation in art. I. Title.
 ND237.A635A4 1998
 759.13—dc21 98-2953
 CIP

With thanks to Susan Bradley

Introduction: A John, a Gabinetto—a Toilet

Right off, you notice the rich colors, the strong, supple shapes, the confident composition, the wide variety of styles. And then within these splendid paintings you see them: toilets. Dreamlike toilets. Comical toilets. Abstract toilets. Flowered and fruited and jeweled toilets. Shimmering and transparent and translucent toilets. Sacred and profane toilets. Toilets as they might have been imagined by Picasso and Kandinsky, Magritte and Cassatt. By Warhol and Chagall and Kahlo. Toilets as they have been wondrously portrayed by one extraordinary artist, Anne Anderson.

Eighty-one-year-old Anne Anderson has been painting and drawing and sculpting for nearly forty years. Her work runs the gamut from the starkly serious to the outrageously playful. An "O'Keeffe" toilet sports an awesome cow skull, and a gold-leafed "Klimt" toilet supports the head and long hair of one of his lovely ladies. Whether Anderson is dealing with the sublime or the ridiculous (or both simultaneously), all her work is characterized by a fine intelligence, excellent craftsmanship, a deep and abiding love of life, and a seemingly irresistible itch to test boundaries and step on over to the other side. Hence, toilets. Toilets as great and famous artists might have painted them…but didn't. Somebody had to do it. And this rambunctious great-grandmother from beside the San Francisco Bay was just the one for the job.

Anne tells us, "I did a larger-than-life painting of my bathtub once; then I painted my bathroom sink. Next, I considered my toilet. It's a wonderful object, really, fluid

and complex. We've had so many artists willing to take risks, to take on 'forbidden' topics—but they've all ignored the toilet. I decided to try to make up for all that neglect."

When viewing Anne's toilets, rendered in the style of twenty-five famous artists, remember that these are not their drawings; they are hers. Homages, to be sure, but much more as well. These striking paintings are rich, funny, haunting, beautiful, strange, remarkable images from a remarkable artist—a little old(er) woman with a big talent and a grand vision.

So whose work has Anne parodied in each of her fabulous paintings? Do you recognize the artists' celebrated styles? Do the titles give you a hint? Be sure to guess whose work you think is being represented on each page. (Answers are at the back of the book!)

HEADS OF THE MASTERS

Pop Cans

He was originally a commercial artist, working as an illustrator for magazines and newspapers. A devout Catholic, he was also a devout capitalist and a compulsive shopper. He celebrated post-war consumerism in his art, awarding the same significance to everyday and mass-produced items as to epic subjects. The founder of Pop Art, his paintings were often based on comic strips and advertisement subjects. An avid fan of the famous, he also painted celebrities with an iconic quality.

He repeated images to the point of nearly draining them of meaning, challenging the perception that art is meant to convey emotions. Further shocking the art world, his assistants worked with him in The Factory, where he defied the concept of unique artwork.

BORN IN PENNSYLVANIA, USA, AUGUST 6, 1928;
DIED IN NEW YORK, USA, FEBRUARY 22, 1987 (AT AGE 58).

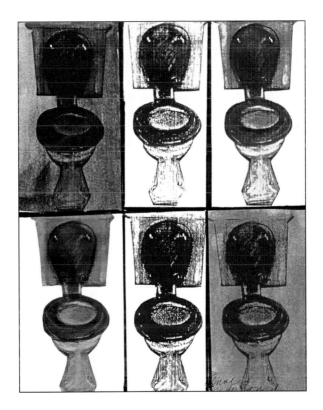

Going Out of My Head

He only actively painted for ten years, during which time he produced 1,000 watercolors, drawings, and sketches and 1,250 paintings.

His father was a minister, and religion was a strong influence throughout his life. After unsuccessful endeavors working for an art dealer and as a lay preacher, he turned to painting. Self-taught far from the influences of Paris, his early paintings were dark in theme and color. Then he discovered he could convey emotions with dramatic and vibrant colors. Aiming to be a peasant painter, he primarily painted the surrounding fields and orchards and the workers in them.

He painted numerous self-portraits to develop his figure painting skills. If he thought a portrait was good, he kept the original, made a copy for his brother Theo, and made another copy for the sitter.

BORN IN HOLLAND, MARCH 30, 1853; DIED IN FRANCE, JULY 29, 1890 (AT AGE 37).

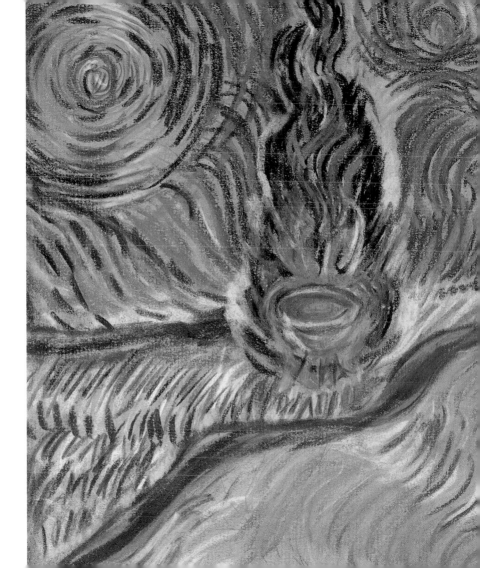

The Seat of Enchantment

She rejected the classic teachings of her art schools, developing her own style. Influenced by abstract art, she pioneered modernism in the U.S., using ovoids, ellipses, and other organic geometries in her landscapes. Inspired by the desolate beauty of New Mexico, she frequently painted the American Southwest, incorporating flowers, crosses, animal bones, clouds, and other natural or found objects.

Her work reflected many photographic concepts, such as cropped images, isolated detail, and magnified close-ups. Her phenomenal enlarged paintings of flowers stunned the art world, and critics pronounced them sexually suggestive. A reclusive, opinionated woman who lived to ninety-eight, she painted as she pleased.

BORN IN WISCONSIN, USA, NOVEMBER 15, 1887;
DIED IN NEW MEXICO, USA, MARCH 6, 1986 (AT AGE 98).

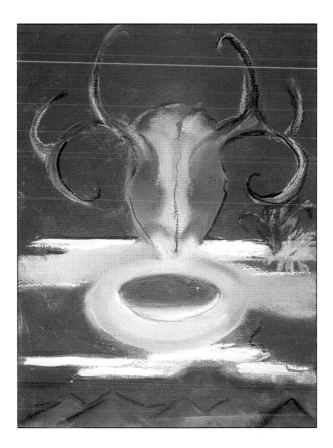

Johnny on the Spot

A very introspective man, he was fascinated with Surrealism, which exemplified the absurd and bizarre images that represent the unconscious and the notion that there was no need for logic in dreams. He placed great value on paintings by untrained amateurs, by children, and by the insane—artists whose work sprang from pure creative impulses, unrestrained by convention.

His art appears spontaneous, rejecting traditional images and devices and achieving a balance between sophistication and innocence. His shapes are almost magical: fantastic shapes that suggest living organisms. The aspect of movement —a kind of ebb and flow—often created a dialogue between two or more figures in his works.

BORN IN SPAIN, APRIL 20, 1893; DIED IN SPAIN, DECEMBER 25, 1983 (AT AGE 90).

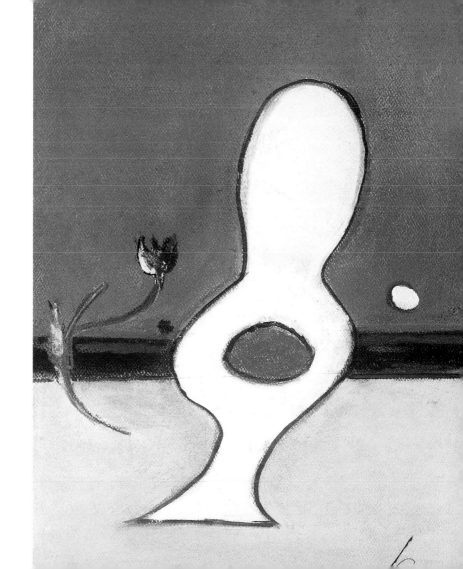

Ode to a Porcelain Palace

His first job at age fourteen was as a bookkeeper. Later, after attending Ecole des Beaux-Arts, he joined the Fauvist movement, painting with glowing colors and sweeping brushstrokes.

Rather than realistically representing images, his brilliant colors reflected what he saw and felt about a scene. Juxtaposed areas of color and stylized forms generated a sense of animation, expressing his love of crowds and movement. His light-hearted, airy art reflected a real sense of joie de vivre.

An interest in seaside subjects, dating back to his childhood in the coastal town of Le Havre, resurfaced in his later years. Spending much of his time on the French Riviera, he often painted resort scenes that glorified the French culture.

BORN IN FRANCE, JUNE 3, 1877; DIED IN FRANCE, MARCH 23, 1953 (AT AGE 85).

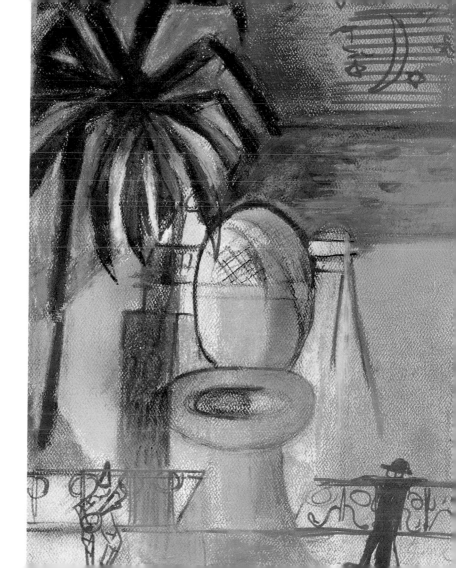

Fruit of the Loo

From a distinguished Milanese family that claimed several archbishops, his father was also a painter. He joined imperial service in 1562 as a painter with Emperor Ferdinand I and the Hapsburgs in Vienna. After many years of loyal and acclaimed work, Rudolf II confirmed him as a nobleman in 1580.

A love for paradox was popular during the Renaissance to which he added his own belief that it was equally important to tell a joke and to take a joke. His art espoused these ideas in a most unusual way: he painted members of the royal court composed of objects such as fruits and vegetables! Flowers, books, utensils, and grains all combined to create bizarre, yet recognizable, faces of famous people.

BORN IN ITALY, 1527; DIED IN ITALY, JULY 11, 1593 (AT AGE 66).

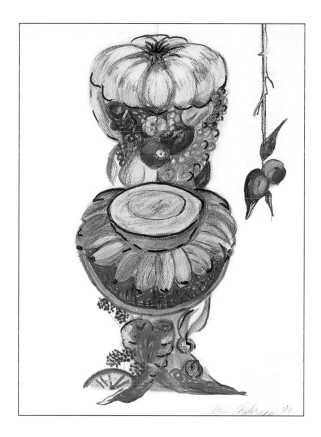

A Head of Many Colors

One of the leading artists of the twentieth century, he failed his first entrance exam to Ecole des Beaux-Arts (though he did pass later).

Rather than working in his father's grain business, he earned a degree in law. Bored at a desk, he went to art school. Impressionism was the reigning style at the time, but one teacher placed unusual emphasis on the use of color. Profoundly inspired, he led a new movement called Fauvism—assigning color an important, expressive role in paintings. His sensual colors were sometimes daringly brilliant, reflecting his surroundings as he painted in France and, occasionally, in Africa.

Painting soothed him, and he continued to paint through his older years, completing the Chapel of the Rosary in Vence, France, while confined to a wheelchair.

BORN IN FRANCE, DECEMBER 31, 1869; DIED IN FRANCE, NOVEMBER 3, 1954 (AT AGE 85).

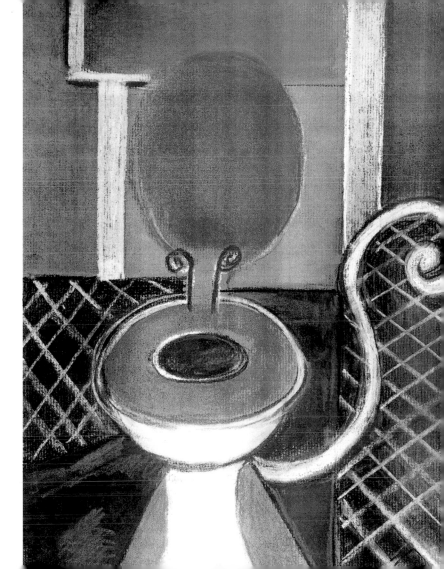

A Throne of Gold

One of the great decorative painters of the twentieth century, much of his work had a gold-encrusted style, featuring gold discs and swirls. This fascination with gold's shimmering beauty surely came from his father's trade, who, though unable to provide for his family, was a gold engraver.

Most of his income came from painting portraits. He declared his main interest in life was "other people, above all females." This interest in women went beyond everyday portraits, and much of his work had an erotic component.

Ornamentation often concealed sexual subject matter in his paintings (his drawings were more explicit!). In *The Kiss*, colors and shapes visually express the emotional and physical explosion of erotic love.

BORN IN AUSTRIA, JULY 14, 1862; DIED IN AUSTRIA, FEBRUARY 6, 1918 (AT AGE 57).

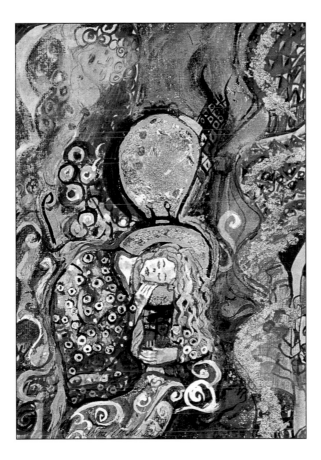

A Melting Pot

His "hand-painted dream photographs" were filled with hidden meanings and, like dreams, everything the viewer saw was potentially something else. Watches melted and Mae West's lips became a sofa. Objects were painted out of proportion, out of context, and out of this world.

A Surrealist, he was fascinated by Freud's work and the ideas that dreams express unconscious desire and that paranoia is just a delusional viewpoint. He painted impossible, hallucinatory scenes with such meticulous realism as to be disturbing. His paintings also frequently featured an obsession with doubles that can be traced back to his childhood: he was named after a recently deceased brother. Further confounding his duality, his father was an atheist with radical political beliefs while his mother was a Roman Catholic.

BORN IN SPAIN, MAY 11, 1904; DIED IN SPAIN, JANUARY 25, 1989 (AT AGE 84).

Ocupado?

A bus accident left her seriously crippled at the age of sixteen. Undergoing thirty-two operations over the following years, she never fully recovered. She started to paint while first recovering from the accident, and most of her two hundred paintings were self-portraits, dealing with her ongoing battle to survive. Painting helped her hold on to reality while separating herself from her pain—both her physical suffering and the emotional distress of never being able to have children.

She painted on a small scale, using fantasy and a primitivistic style to help distance the viewer from her disquieting subject matter. Inspired by the remarkable collection of folk art that filled her rooms, she brought her world to us. Monkeys, hummingbirds, and the jungle surrounded her in her art as it did in real life.

BORN IN MEXICO, JULY 6, 1907; DIED IN MEXICO, JULY 13, 1954 (AT AGE 47).

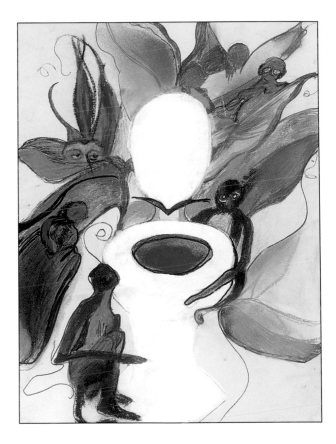

Chamber Music

A brilliant and persuasive man, he first trained as a lawyer, later becoming a teacher and theoretician as well as a practicing painter. He believed that art's expressive function is communication. Influenced by the Fauves, he used color to convey ideas, sometimes smearing and smudging the colors for emphasis.

As a leading abstract artist, much of his work focused on geometric shapes, especially circles. He considered a circle to be the most elementary form, having a symbolic, cosmic meaning. Later work featured organic forms such as embryos and cells.

An accomplished musician, he said, "Color is the keyboard, the eyes are the harmonies, the soul is the piano with many strings. The artist...causes vibrations in the soul." He claimed that he heard music when he saw color.

BORN IN RUSSIA, DECEMBER 4, 1866; DIED IN FRANCE, DECEMBER 13, 1944 (AT AGE 78).

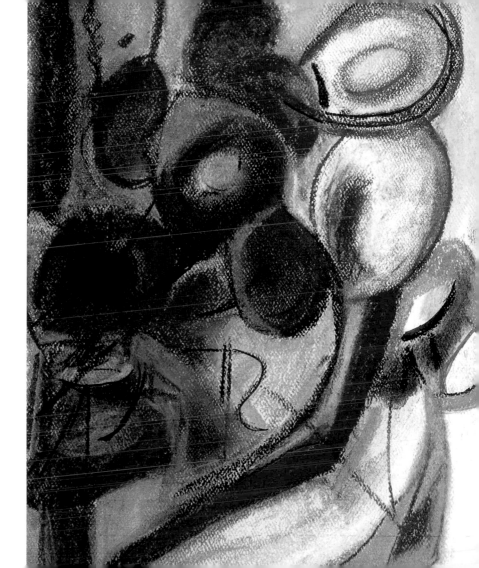

Fabled Heads

He served as Commissar for the Arts in his native Vitebsk after the Bolshevik Revolution of 1917. And though he eventually left the Soviet Union due to political differences, his art always reflected his beloved Russia.

His poignant images—incorporating mythological subjects and folkloric imagery from his Jewish and Russian roots—came from the heart, not the head, and often spoke to the human desire for happiness. Animals and people gazing down upon villages create a poetic sense of destiny. His strong, unique colors add to the fantastic, dreamlike quality of his works.

BORN IN RUSSIA, JULY 7, 1887; DIED IN FRANCE, MARCH 28, 1985 (AT AGE 98).

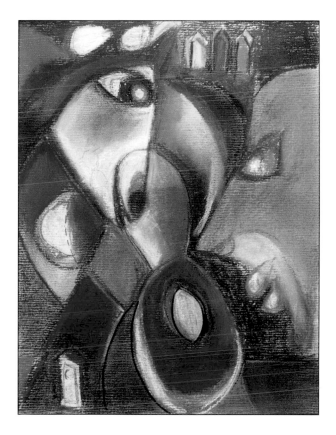

And If It Is Not a Toilet?

Influenced by Impressionism, then Realism, Futurism, and even Cubo-Futurism, he became a leading Surrealist and one of the greatest Belgian artists of the twentieth century.

His art is painted with great clarity and appears highly realistic, typifying the Surrealist love of paradoxical visual statements, and though things may seem normal—especially with his deadpan style—there are absurdities everywhere. He mischievously expressed life's oddities with such creations as his man in the bowler hat.

Text was also an important element in his work. Inscriptions reminded us that the image on the canvas, no matter how precise, was not the actual three-dimensional object, but merely a rendering of it.

BORN IN BELGIUM, NOVEMBER 21, 1898; DIED IN BELGIUM, AUGUST 15, 1967 (AT AGE 68).

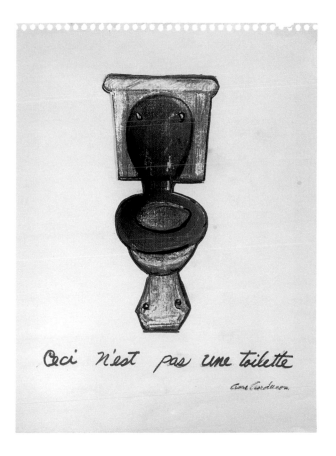

Ceci n'est pas une toilette

A Very American Standard

He grew up and attended art school in Connecticut, and his early landscapes reflected these cherished surroundings. He later painted strong, simple figurative shapes with odd and distorted aspects, reducing his forms to the purest possible abstractions, while always retaining his commitment to working from nature.

Profoundly influenced by European modernism and its expressive use of color, his colors were truly luminous—shimmering rhythms simultaneously pastel and opulent—and he was often called the "American Matisse." His serene and harmonious work projected a feeling of quiet and beauty.

BORN IN NEW YORK, USA, MARCH 7, 1893;
DIED IN NEW YORK, USA, JANUARY 3, 1965 (AT AGE 71).

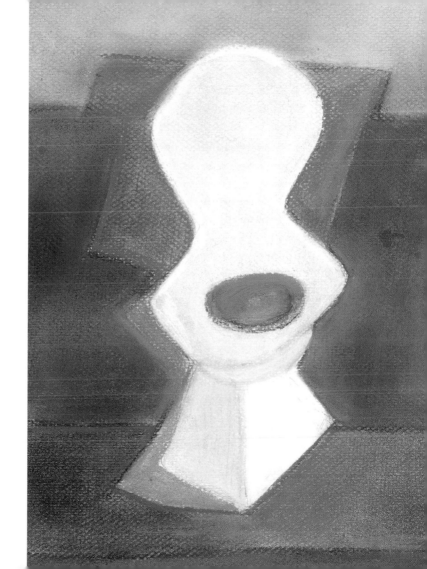

A Can Is a Can Is a Can

One of the leading artists of the twentieth century, he was also a very public figure. His life and works—he was an enormously productive and prominent artist throughout his long life—were presented extensively in books and on film. His artistic personality and bohemian lifestyle came to be viewed as the quintessential image of the modern artist.

Reflecting his life in his art, he often painted the women he was involved with. The waxing and waning of each relationship was clearly mirrored from periods of bright, gay work to portraits featuring harsh and distorted images.

Famous for his Blue Period and his Rose Period, he created Cubism with Georges Braque. It was during his transition period to Cubism that he painted a portrait of Gertrude Stein—one of his most important patrons—which took over eighty sittings.

BORN IN SPAIN, OCTOBER 25, 1881; DIED IN FRANCE, APRIL 10, 1973 (AT AGE 91).

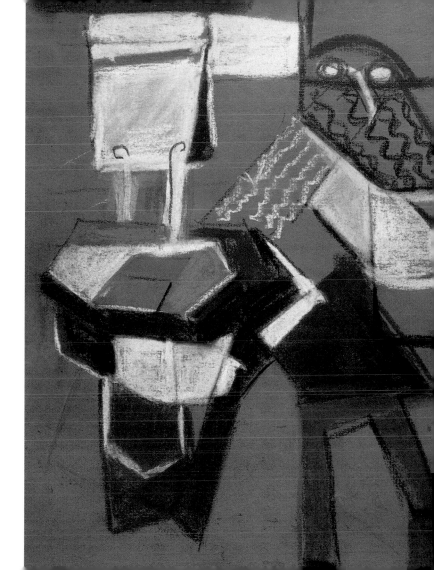

Privy to the Unknown

Originally from Greece, he fought with Italy in World War I. When he returned from the war, his paintings developed a haunting quality. Spaces were dislocated and melancholy, closed in by high walls. Images appeared to lurk in anticipation of whatever was around the corner. An apparently silent world emoted a sense of uneasiness.

A student of Nietzsche's philosophy, he painted to reveal the true essence behind everyday and commonplace scenes. His enigmatic paintings were characterized by a visionary, poetic use of imagery, which led to his originating *pittura metafisica* —metaphysical painting.

Though criticized for it, at one point in his life, he painted copies of his own earlier famous works, selling some of them as the original.

BORN IN GREECE, JULY 10, 1888; DIED IN ITALY, NOVEMBER 20, 1978 (AT AGE 90).

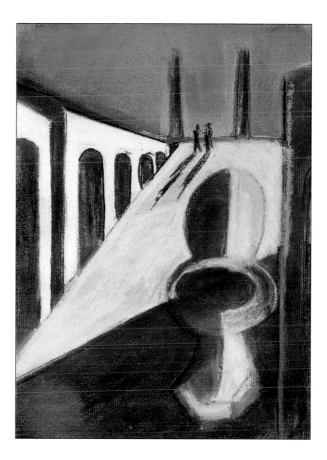

God Bless the Child Who's Got Her Own

Though originally from America, she moved to France as a young adult to pursue her art. Deviating from the popular Salon masters of the 1870s, she developed her own style, after which Degas invited her to exhibit with the Impressionists.

She is particularly associated with the theme of mother and child, though she never married or had children of her own. Unlike most women during her lifetime, when faced with the dilemma of pursuing her work or marrying and having a family, she made the radical choice to continue painting. Her parents and older sister came to live with her in Paris, and her two brothers and their families visited often, providing many subjects for her Impressionist portraits and scenes of daily life.

BORN IN PENNSYLVANIA, MAY 25, 1844; DIED IN FRANCE, JUNE 14, 1926 (AT AGE 82).

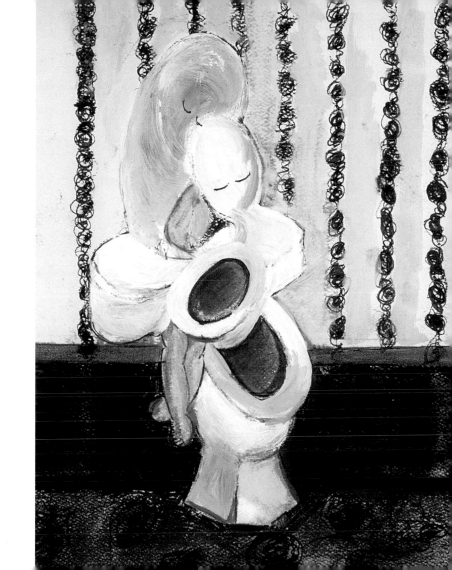

Down the Hall and to the Left

He strove to denaturalize art, to abstractly represent objects in their purist sense, painting to express only spiritual essences—the thoughts and feelings that symbolize cosmic order. A founder of modern art, he used geometric shapes to represent the dynamic pulse of life and the ideal of universal harmony.

He believed that painting, composed of the most fundamental aspects of line and color, must set an example to the other arts for achieving "beauty" within a society.

Originally using unusual and distinctive colors, such as orange and purple, he came to restrict his paintings to primary colors and black, white, and grey, using straight lines to divide his canvases. These austere works—showcasing the relationships between the colored areas and lines—nevertheless, are immensely dynamic.

BORN IN HOLLAND, MARCH 7, 1872;
DIED IN NEW YORK, USA, FEBRUARY 1, 1944 (AT AGE 72).

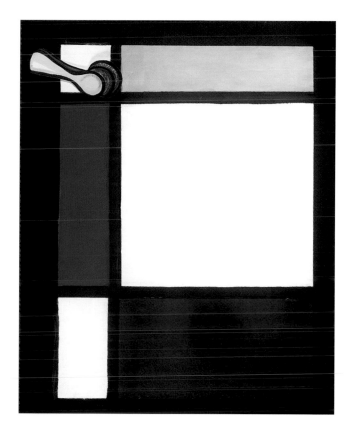

Please Don't Squeeze the Shaman

Untrained as an artist, he originally studied philosophy. This influenced his art both technically—he invented several new techniques throughout his career, including dripping paint from a suspended, swinging can—and in content. Horrified by the atrocities of World War I, his early imagery was violent and menacing.

Influenced by Freud's work on dreams and the power of the unconscious, he studied artwork done by the insane. Joining the Surrealist movement, his work frequently incorporated childhood memories, offering us a sense of his personal mythology.

Furthering his philosophical pursuits, he studied shamanism when he lived in Sedona, Arizona. Having often been preoccupied with bird imagery, he now called himself the child of an eagle.

BORN IN GERMANY, APRIL 2, 1891; DIED IN FRANCE, APRIL 1, 1976 (AT AGE 85).

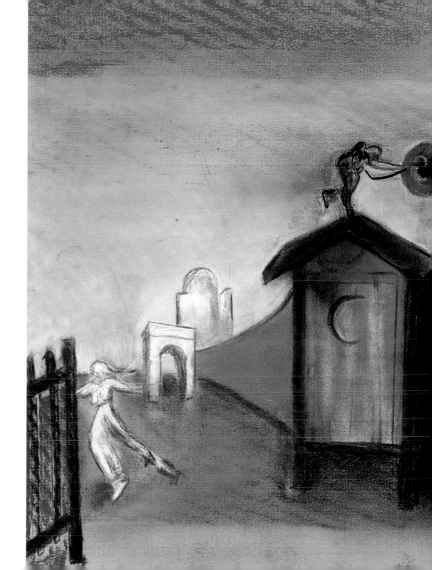

From Bauhaus to Outhouse

He lived in Germany for many years, teaching basic design and color theory at the Bauhaus schools. As a nonconformist intellectual, he had to flee the country in 1933 when the Nazis were in power.

An inventive modern artist, his work had a naive, untutored quality, yet was very cerebral with a sense of humor and mystery. He was also a great colorist and declared, "Color and I are one. I am a painter."

His father was a music teacher, and he studied violin, continuing to play throughout his life. He believed deeply in the spiritual nature of artistic activity and compared color to music, believing both were capable of transporting our senses beyond rational comprehension. Influenced by the beauty of music, he considered line and tonality to be critical aspects of a painting.

BORN IN SWITZERLAND, DECEMBER 18, 1879;
DIED IN SWITZERLAND, JUNE 29, 1940 (AT AGE 60).

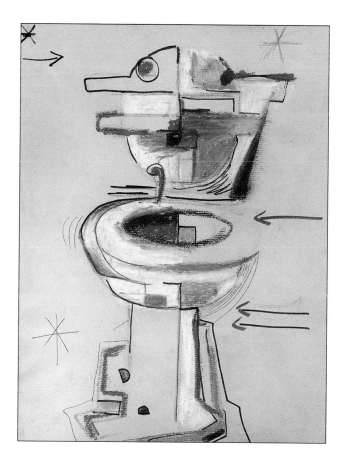

Natural Amenity

Though he never traveled, he often painted exotic subjects in his brightly colored, dreamlike paintings. Prints in travel magazines and the tropical hothouse in Paris provided models for his jungle landscapes.

Self-taught and therefore unhampered by formal training, he was the first major Naive artist. His work was rarely lifelike, and he had an odd way of stiffening and flattening subject matter, yet such imperfections reinforced a childlike intrigue in his work.

His "peers" eventually accepted his work. In 1908 Picasso held a banquet in his honor. Extremely confident, he exaggerated his sense of importance as an artist, saying to Picasso, "We are the two great painters of our time, you in the Egyptian style, I in the modern style."

BORN IN FRANCE, MAY 21, 1844; DIED IN FRANCE, SEPTEMBER 2, 1910 (AT AGE 66).

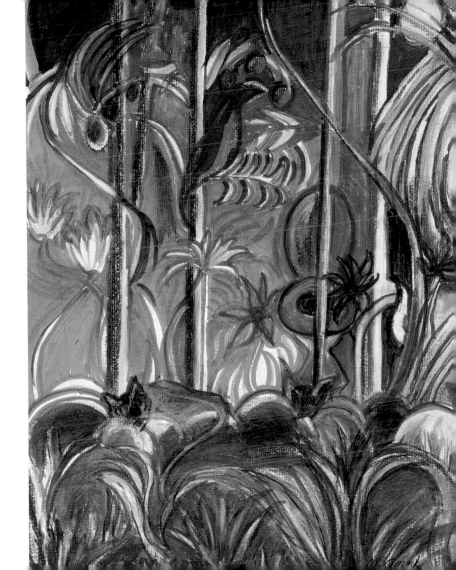

A Long, Lean Latrine

He already saw himself as an artist at age thirteen and studied painting plein air. He was equally enamored of sculpting and was sorely disappointed that he could not sculpt much due to his poor health—he was always weak and occasionally ill due to poor lungs.

Perhaps due to the autobiographical nature of his work—mainly painting friends, lovers, and colleagues—he developed an awesome ability to express human emotions in his portrait's faces. His work had a wonderful slow elegance, unusual and compelling, and he is famous for his distinctive, elongated faces and forms.

BORN IN ITALY, JULY 12, 1884; DIED IN FRANCE, JANUARY 24, 1920 (AT AGE 35).

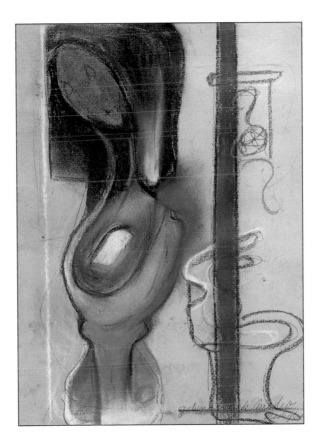

An Existential Fixture

His father was a Post-Impressionist and Fauvist painter, and he became both a sculptor and a painter. He was considered an Existentialist, and the subjects in his paintings were interpreted as being in a void. His friendship with Jean-Paul Sartre led him to "see" figures as if at a distance.

Such angst was reflected in somber, anonymous figures, seemingly isolated in space—appropriate metaphors for post-World War II Europe with its many displaced persons and destroyed lives.

He often worked on a series featuring one particular element or theme at a time, painting interwoven lines, usually black, white, red, and yellow, overlaid with darker smudgings. A twenty-year hiatus from painting and a tendency to wipe out his day's work each night made his surviving works even more precious.

BORN IN SWITZERLAND, OCTOBER 10, 1901;
DIED IN SWITZERLAND, JANUARY 11, 1966 (AT AGE 64).

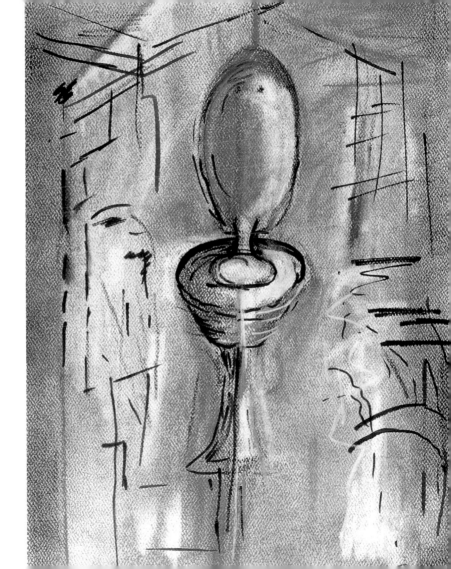

A Cosmic Convenience

An abstract artist during the machine age, he was influenced by Cubism and used geometric forms extensively. He considered circles, especially, to exemplify cosmic symbols.

Color and contrast were equally critical to his vision, and he was a master of color composition. The interplay of colored forms created movement, while groupings of them defined figures and objects.

His style, named Orphism, embraced the idea that color, light, music, and poetry were associated arts. He called his art "pure painting," with color contrasts representing the intersection of light, space, and movement.

BORN IN FRANCE, APRIL 12, 1885; DIED IN FRANCE, OCTOBER 25, 1941 (AT AGE 56).

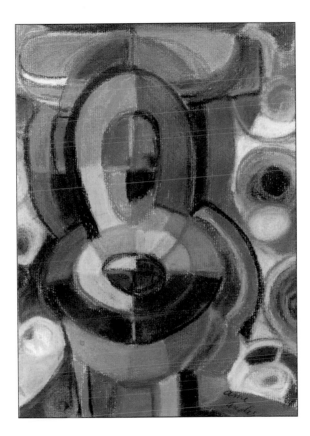

Large Scale Relief

She grew up in Maine where her father operated a lumberyard, which apparently influenced her future "assemblages."

Many artistic influences inspired her, including Surrealism, African art, Native American art, and pre-Columbian art. At one point she worked with Diego Rivera on his socialist murals. She was most significantly affected by Cubism and the techniques of collage.

She used found objects, such as chair backs, furniture legs, and architectural ornamentation, for her large-scale reliefs that she called "environments." Then she painted all the objects one color to obscure their original identity and function, formally unifying them into one structure. Her use of durable materials led to numerous commissions for outdoor sculptures.

BORN IN RUSSIA, SEPTEMBER 23, 1899;
DIED IN NEW YORK, USA, APRIL 17, 1988 (AT AGE 88).

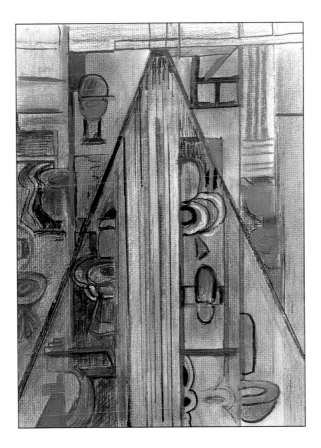

About the Artworks

Pop Cans, 8-1/2" x 12" © 1994 by Anne Anderson
Going Out of My Head, 9" x 12" © 1994 by Anne Anderson
The Seat of Enchantment, 9" x 12" © 1994 by Anne Anderson
Johnny on the Spot, 9" x 12" © 1994 by Anne Anderson
Ode to a Porcelain Palace, 9" x 12" © 1994 by Anne Anderson
Fruit of the Loo, 9" x 12" © 1994 by Anne Anderson
A Head of Many Colors, 9" x 12" © 1994 by Anne Anderson
A Throne of Gold, 8-1/2" x 12" © 1994 by Anne Anderson
A Melting Pot, 9" x 12" © 1994 by Anne Anderson
Ocupado?, 9" x 12" © 1994 by Anne Anderson
Chamber Music, 9" x 12" © 1994 by Anne Anderson
Fabled Heads, 9" x 12" © 1994 by Anne Anderson
And If It Is Not a Toilet?, 9" x 12" © 1994 by Anne Anderson
A Very American Standard, 9" x 12" © 1994 by Anne Anderson
A Can Is a Can Is a Can, 8-1/2" x 12" © 1994 by Anne Anderson
Privy to the Unknown, 9" x 12" © 1994 by Anne Anderson
God Bless the Child Who's Got Her Own, 9" x 12" © 1994 by Anne Anderson
Down the Hall and to the Left, 8-1/2" x 12" © 1994 by Anne Anderson
Please Don't Squeeze the Shaman, 8-1/2" x 12" © 1994 by Anne Anderson
From Bauhaus to Outhouse, 9" x 12" © 1994 by Anne Anderson
Natural Amenity, 9" x 12" © 1994 by Anne Anderson
A Long, Lean Latrine, 9" x 12" © 1994 by Anne Anderson
An Existential Fixture, 9" x 12" © 1994 by Anne Anderson
A Cosmic Convenience, 8-1/2" x 12" © 1994 by Anne Anderson
Large Scale Relief, 9" x 12" © 1994 by Anne Anderson

More Gift Books from Papier-Mache Press

I Shall Wear Purple, papier-petite™
Edited by Sandra Haldeman Martz
ISBN 1-57601-036-8, hardcover

The million-copy bestseller by award-winning anthologist Sandra Haldeman Martz is now available in an abridged purse-size version. This inspiring collection of poems, stories, and photographs includes the famous title poem by Jenny Joseph that started the purple craze. Millions of women have taken its message to heart: it's OK to grow older; in fact it's terrific! This small treasure edition is a wonderful gift for every woman you know.

"You're not getting older, just a little more purple." —*Milwaukee Journal Sentinel*

If I Had My Life to Live Over, papier-petite™
Edited by Sandra Haldeman Martz
ISBN 1-57601-031-7, hardcover

The wildly popular companion volume to *When I Am an Old Woman I Shall Wear Purple* is now available in an abridged purse-size version. Insightful poems, stories, and photographs focus on the small private decisions women make that live vividly in our memories. Includes the title poem by Nadine Stair.

"Touches on every aspect of women moving on in life." —*Small Press Review*

The Best Is Yet to Be, papier-petite™
Edited by Sandra Haldeman Martz
ISBN 1-57601-032-5, hardcover

Following the overwhelming response to the mini version of *When I Am an Old Woman I Shall Wear Purple,* an abridged purse-size version is now available for its fellow volume on aging. This delightful book celebrates wisdom and strength, friendship and passion, and is the ideal gift for parents, grandparents, and other loved ones.

"Nothing could be more timely than this book." —Studs Terkel

Papier-Mache Press

At Papier-Mache Press, it is our goal to identify and successfully present important social issues through enduring works of beauty, grace, and strength. Through our work we hope to encourage empathy, respect, and communication among all people—young and old, male and female.

We appreciate you, our customer, and strive to earn your continued support. We also value the role of the bookseller in achieving our goals. We are especially grateful to the many independent booksellers whose presence ensure a continuing diversity of opinion, information, and literature in our communities. We encourage you to support these bookstores with your patronage.

We offer many beautiful books and gift items. Please ask your local bookstore or gift store which Papier-Mache items they carry. To obtain our complete catalog, mail your request to Papier-Mache Press, 627 Walker Street, Watsonville, CA 95076-4119; call our toll-free number, 800-927-5913; or e-mail your request to papierma@sprynet.com. You can also browse our complete catalog on the web at http://www.ReadersNdex.com/papiermache. To request submission guidelines for our next anthology, write to Papier-Mache Press, 627 Walker Street, Watsonville, CA 95076-4119, or visit our web site.